D0429380

THE LITTLE BLACK DRESS

© 2001 Assouline Publishing
601 West 26th Street, 18th floor
New York, NY 10001
USA
Tel.: 212 989-6810 Fax: 212 647-0005
www.assouline.com

ISBN: 2 84323 289 9

Translated from the French by Ilona Bossanyi
Proofreading: Jennifer Distler

Color separation: Gravor (Switzerland)
Printed by Grafiche Milani (Italy)

All rights reserved.
No part of this publication may be reproduced,
stored in a retrieval system,
or transmitted in any form or by any means, electronic, mechanical,
photocopying, recording, or otherwise,
without prior consent from the publisher.

THE LITTLE BLACK DRESS

VINTAGE TREASURE

DIDIER LUDOT

ASSOULINE

Prologue

The little black dress is an alliance of opposites. Symbolizing the respectable woman with an eye to seduction, the little black dress makes her feel safe and, at the same time, much more dangerous. The dress is a triumph of ambivalence, mischief behind the demure. Between vice and virtue, the fantasy converges.

"Dressing in black means simplicity of line, perfection of cut and a touch of spirit," wrote Suzy Menkes on December 12, 1983, at the Yves Saint Laurent exhibition staged by the Metropolitan Museum of Art.

As she slips on her little black dress, a woman is touched by the spirit of fashion—which is a game of make-believe, playing on what may be, keeping you guessing, or maybe lying.

Worn to flatter or adorn, to be demure or sexy, modest or shameless, sophisticated or minimalist, the little black dress is the eternal symbol of bewitching love.

Be it a mere wisp of transparent black muslin that seems so easily cast aside, the little black dress readily calls up a paraphrase of Coco Chanel: a woman who doesn't wear a little black dress is a woman without a future. *[Mademoiselle Chanel's maxim: A woman who doesn't wear perfume is a woman without a future.]*

The Little Black Dress, An Exercise in Style

She's late. She gets home and sees her guests have already arrived. A moment of panic arises until she slips on her little black dress, dabs on some scent, pats her chignon into place and clips a string of pearls around her neck. She's perfect. She's Jeanne Moreau in Louis Malle's *The Lovers*. She's wearing a Chanel dress.

The magic is in photographs too: Marlene Dietrich recording, with gemstones encircling neck and arms; Maria Callas seen through a mirror; the enticement of Anna Magnani; the ice-cool mystery of Louise Brooks glinting under her pearls; or of Catherine Deneuve in *Belle de jour*.

Here's Danielle Darrieux in *Marie Octobre*, suppressing memories and forebodings, Anouk Aimée in dark glasses in *La Dolce Vita*, Audrey Hepburn and her sublime lace eye mask, wondering how to steal a million dollars, Delphine Seyrig surrounded by the stucco of Amalienburg that's supposed to represent Marienbad, Romy Schneider surrounded by *Max et les ferrailleurs*, radiating ambivalent sensuality.

But there's also the figure, partly-obscured at night in a bistro at Les Halles, mink bolero slipping off bare shoulders over a black dress.

By some mysterious alchemy, the little black dress embodies the woman who wears it like a second skin. They say that black absorbs the contours, but it's a magnet for the eyes. And as we see it through a kaleidoscope of memories, the dress becomes the very essence of the woman. The strange, almost fetishist bond that links a woman to her little black dress means she will rarely give it away. She will treasure its every facet in the timeless depths of her wardrobe.

In Ménilmontant, in the 1940s, a little city sparrow called Edith Piaf brought all of Paris to its feet, with her voice, her cross and her little

black dress. She would have no artifice—the better to magnify her voice. The first time she sang in a simple black dress, she did so because it was all she had, but for the rest of her life she remained faithful to that image, entrusting it later to Christian Dior and Jacques Heim.

"You can wear black at any hour of day or night, at any age and for any occasion. A little black dress is the most essential thing in any woman's wardrobe. I could write a book about black," wrote Christian Dior in 1954.

Before Dior, the infallible Chanel brought the color black out of mourning, away from the clergy, away from the world below the stairs, turning it into the very essence of Parisian chic. In 1926, her "Ford" dress attracted almost as many clients as buyers of automobiles. Its stunning success was exactly in line with trends in a society where women were beginning to relish the pleasures of their new-found freedom. With the First World War, the whole world was turned upside down, and "Little Telegraph Boys," nimble in knee-length dresses and de rigueur slimness, took over from the high society lionesses in demented hats, bespangled odalisques in hobble skirts. "For whom are you in mourning, Mademoiselle?" Paul Poiret asked Chanel. "Why, for you, Monsieur!" she answered. Thus did Coco La Garçonne slay Sheherazade!

first worn by a select few—intellectuals and artists like Kiki de Montparnasse—the little black dress soon became a must for all women of fashion that would hold sway for the rest of the century, quickly crossing the Atlantic with American society ladies in search of the "New Parisian Chic." The 1930s saw the

golden age of the couturier, as Balenciaga came to Paris, the new, unrivaled capital of fashion. Hemlines dropped: bias-cut by Madeleine Vionnet, draped by Madame Grès. But even Nina Ricci's romantic pastels, even the surrealist creations of Elsa Schiaparelli, proved no match for the little black dress that had become a mainstay of every collection and to which each of the couturiers would add their own vision: a jabot here, organdy collar and cuffs there.

When the Second World War broke out and put an end to carefree living, the little black dress joined the resistance. Sleeves were worn long, as a mark of respect for those battling on the war front, plunging necklines were banished as a symbol of collaboration with the enemy. Parisians, fashion-conscious still, discovered the "pouf" from Balenciaga, which they preferred—by necessity—to be removable. The divided skirt, which came in with bicycling for all, was adorned with pockets—like the models everyone swooned over in 1942, from Robert Piguet, Rochas and Carven at number 20, Rue des Pyramides. But fabrics became scarce, and the fashion houses closed down one by one. Women restyled their old dresses, dyed them black, shortened the hems—pre-war dresses, like hats, could often be brought up to date with a wisp of tulle, which you could buy without ration cards.

As soon as the war ended, the little black dress came back with a swing, along with the Zazous at the Tabou club. It became the uniform of the existentialist movement.

It also contributed to the rebirth of haute couture. After five years of hardship, opulence and hyper-femininity made a comeback in a positive riot of fabrics that Christian Dior brought to life with genius in his first post-war collection: the New Look of 1947 made history. In the next year's season, the Diorama dress took up 29 yards of black wool crêpe with a 51-inch width.

Hemlines dropped once more, and so did necklines, bringing out the curves of an uplifted bust. At luncheons, tea dances and cocktail

parties, the little black dress was the star turn in *Vogue, Harper's Bazaar* and *Fémina*. This was the heyday of the lady of leisure, dreamily diaphanous in Dior or Jacques Fath, supremely elegant in Balenciaga's "Menines," deliciously voluptuous in a "Jolie Madame" sheath by Balmain or draped in muslin by Dessès.

After the death of Christian Dior in 1957, Yves Mathieu-Saint-Laurent took center stage. He had joined Dior in 1955, and his own consecration as a couturier came with the Trapèze line. René Gruau was immortalized on the March 1958 cover of *L'Officiel*, thanks to a black dress chosen from the Trapèze collection.

But it was in the sixties that the little black dress reached its apotheosis. It was in the torment of those years that it revealed its true nature: it was indestructible.

t he New Wave in cinema brought a new wave of black-clad heroines to the silver screen. Monica Vitti, black as night in *La Notte*; Anita Ekberg, leading La Dolce Vita in Rome, all in black; Ingrid Bergman too, seducing Anthony Perkins in Paris; and Audrey Hepburn taking Breakfast at Tiffany's in New York. Black was Anna Karina's emblem too, blithely asserting that "a Woman is a Woman," the phrase that made her sparkle brighter than all the rest on the terrace at the Café de Flore under the enraptured gaze of Jean-Luc Godard. Jeanne Moreau conducted her dangerous liaisons in black, was immortalized as the *The Bride Wore Black*; and with a black-clad Brigitte Bardot, no soldier could take his leave.

With a straight, simplified cut, the little black dress, now available in High Street thanks to the flowering of off-the-rack boutiques, became the thing to wear for the middle-class woman, with pearls at

her throat and a chignon by Alexandre at the nape of her neck. She made it a "must," though paradoxically enough, it was often the only black item in her wardrobe.

The most Parisian of all American ladies wore a sleeveless black dress with a jewel neckline—to please Charles de Gaulle during the Presidential tour. It was on this occasion that John F. Kennedy made his celebrated remark: "I'm the man with Jackie." That day a legend was born: Jackie Kennedy's three-hole dress has endured to this day as an important reference in fashion.

The little black dress signed by Balenciaga became irresistible to society ladies from the Duchess of Windsor to Mona von Bismark, who was magnified by Dalí, barefoot, in a little black dress. In black muslin, it enchanted everyone who swore by Mademoiselle; in jersey, it took the fans of Cardin-the-futurist by storm.

Yves Saint Laurent, who founded his own establishment in 1961 with Pierre Bergé, decreed that black was a color for every hour of the day. The see-through dress was born—in black.

Its "mini" version came dancing onto the scene with Castel and Régine. Courrèges bowed to its ubiquitous presence by including it among the pastel colors of his collections.

Flying a red scarf, this symbol of the bourgeoisie adapted to a new economic and social context, casually leaping the barricades of May 1968. There was a point, then, when the little black dress—perhaps tiring at last after living through so much—might have vanished along with the magician who created so many "great" little black dresses. Balenciaga, once more rejecting the new off-the-rack market, closed his fashion house. But the rowdy, dishevelled, multicolored threat that materialized as Flower Power forced it to turn about once again: flashing with plastic flowers by Dior's Marc Bohan, with shiny vinyl strips on supple knits by Cardin, the little black dress kept on going. Yves Saint Laurent dropped its hemline, reinvented it as a shirt

dress, and made it the image of a generation of women who, like Edmonde Charles-Roux and Françoise Giroud, proved that intellectual courage could go hand in hand with sexy chic, as symbolized so elegantly and ambiguously by Stéphane Audran and Delphine Seyrig in Luis Buñuel's *Discreet Charm of the Bourgeoisie.*

toward the end of the sixties, the little black dress made a comeback among the upcoming designer generation: Mugler, Montana, Beretta, Gaultier and Alaïa, who together changed the course of fashion entirely. The little black dress became the emblem of the young jet set, who—with Paloma Picasso as their figurehead—would whirl the nights away at New York's Studio 54 or at the Palace in Paris. Meanwhile, the teenage generation, aided and abetted by Agnès B, took to wearing a little black dress in the schoolyard. And so, gradually losing its exclusively ultra-feminine image, the little black dress gained yet more ground.

In 1983, Karl Lagerfeld's arrival at Rue Cambon woke that establishment from its slumber. With a nod and a wink to the "Ford" dress, his top model, Inès de la Fressange, ended each show in Chanel black.

And now, with wide shoulders, nipped-in waistline, perched on stiletto heels and as aggressively curvaceous as a comic strip heroine by Antonio, the little black dress took on new guises. In leather or latex, studded with strass, it strode out in a Mugler or Montana version to stun the black-clad crowds in the Cour Carrée, while Azzedine Alaïa shaped it in jersey and lycra to magnify the bodies of unreachable goddesses all in black.

With the advent of minimalism in the 1980s, black returned with a vengeance and for a long time to come. With its unique identity

11

intact, the little black dress began riding the new wave of Japanese couture, with Issey Miyake, Rei Kawakubo and Yohji Yamamoto.

But being the darling of every designer, however talented and creative, was still not enough for this archetype of Parisian sophistication and quintessential chic. And here came that troublemaker of genius, revolutionizing the world of Parisian haute couture: Christian Lacroix, who would use the little black dress as an exclamation mark.

In the 1990s an inspired designer from Milan came onto the scene. This was Miuccia Prada who, using leftover nylon stocks from her family's umbrella factory, forced the textile mills into a new line of thinking. The age of technology had arrived. Armed with its branded belt, the "Petite Prada" hit the headlines to become the prerogative of a whole generation of young people who had chosen the color black. The dress returned to its place of honor in every fashionable wardrobe. Mothers' and daughters' tastes in fashion could strengthen, broaden and converge around the little black dress, reflecting the permeability between generations that characterizes our time.

From Calvin Klein to Donna Karan, from Anne Demeulemeester to Josephus Thimister and Martin Margiela, from the Austrian Helmut Lang to the German Jil Sander, all the new big names in fashion tried to make the little black dress their own, in umpteen variations on their grunge and minimalist styles. Realizing that the dress had become a kind of obligatory initiation in the eyes of the press and fashion professionals, every one of them went ahead with their own exercise in style, with a sense of taking a crucial test in their careers. Even the daughter of Pucci, the grand master of the psychedelic print, found she had to slip a little black dress or two into her shows to modernize her image. Jean-Paul Gaultier and Thierry Mugler, newcomers to the fashion world, would sing its praises at every show. Tom Ford caught on too, elevating the little black dress to stardom with Gucci, and later with Yves Saint Laurent Rive Gauche. Nicolas Ghesquière,

suffused with the master's flair, reinterpreted it for Balenciaga while Helmut Lang flourished it like a banner. But it was when two eccentric and exceptionally gifted foreigners—John Galliano with Christian Dior and Alexander McQueen with Givenchy—brought the little black dress, decadent and indecent, to their haute couture rave parties, that its glamour was reinvented at last.

a s the new millennium begins, the fashion basic has once again become the symbol of femininity. After making its mark on the aristocracy of fashion, the little black dress, like the T-shirt, jeans and trench coat, has become one of the very few absolute fashion essentials of our time, one that every woman must have in her wardrobe. And if we're seeing teenage girls swapping their Nikes and jeans for a little black dress to surprise and seduce the boys at a rave, it's because the mass market has taken hold of it as well, bringing it—sometimes felicitously, sometimes not—within reach of everyone's purse.

Now the youngest age group of all has been conquered: Sonia Rykiel's little girls, joining their black-clad elder sisters in their little dresses for special occasions, with an awakening sense of glamour. Like trousers for women, the little black dress has made history and become a symbol of modernity. Short, always, sometimes with sleeves, sometimes without, the little black dress is a free spirit in the great open space of fashion, that no designer, no stylist, however gifted, will ever succeed in calling his own.

The little black dress obeys no standards, resists every fad, is fashion incarnate. Independent, often insolent, always sexy and sublimely right, it is an enduring symbol of the eternal feminine.

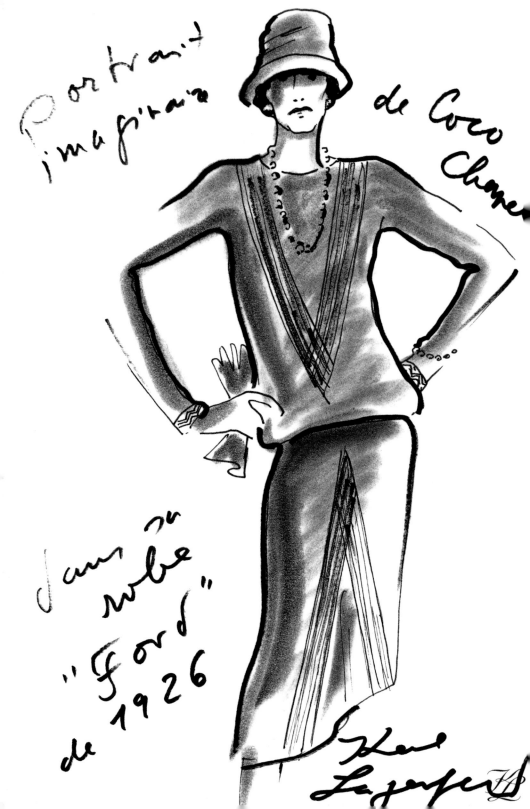

Portrait imaginaire de Coco Chanel

dans sa robe "Ford" de 1926

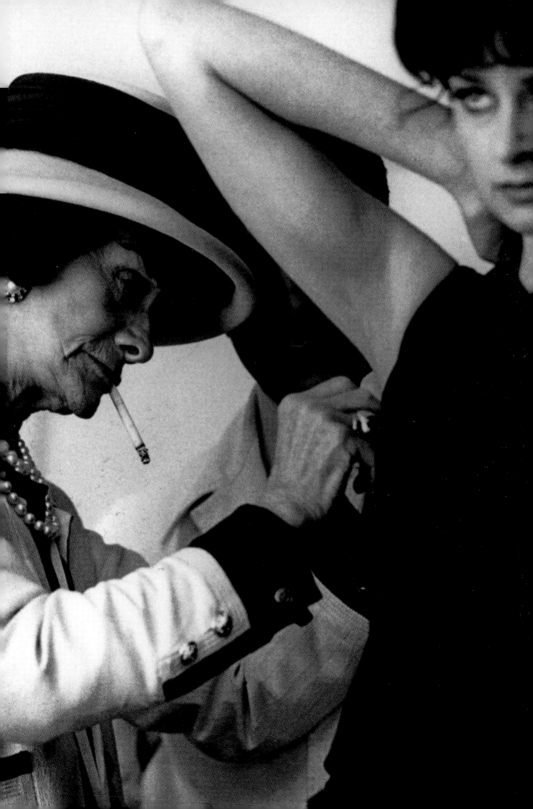

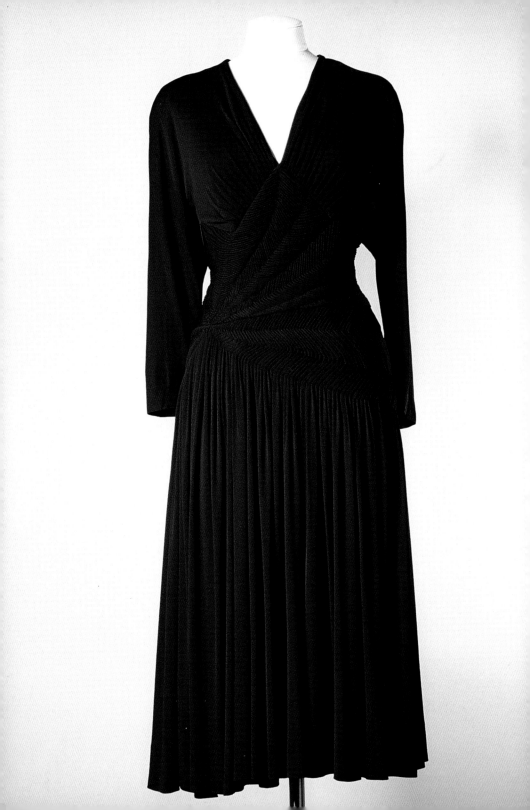

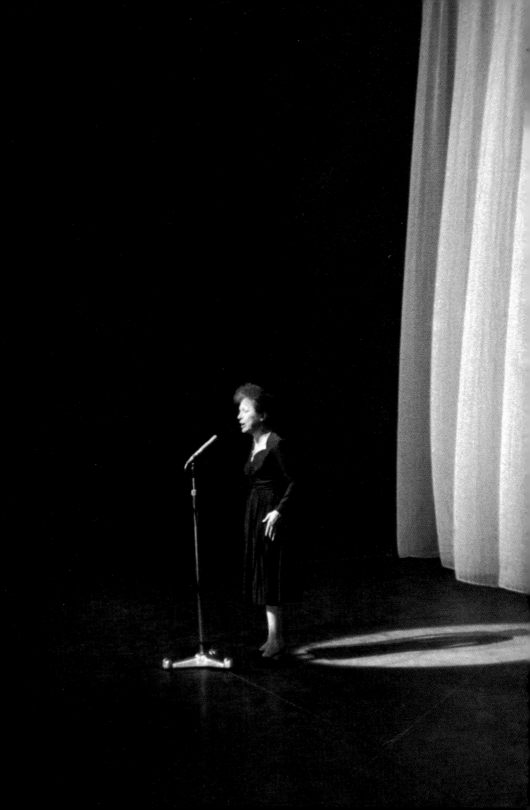

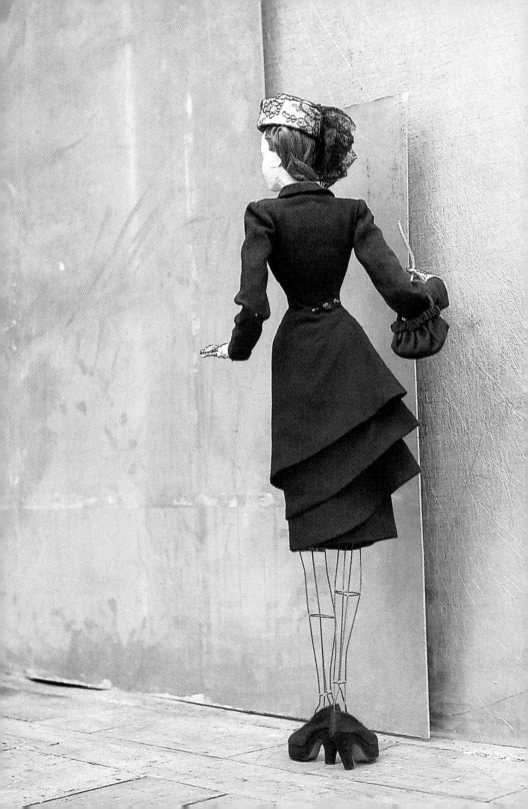

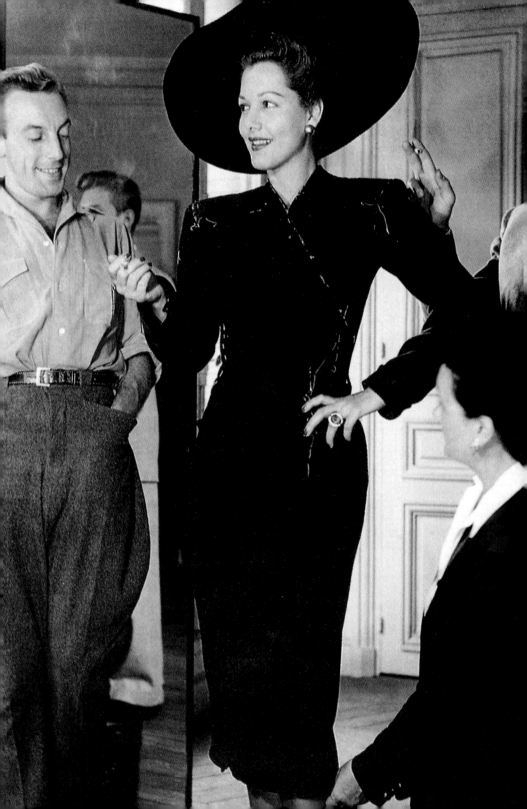

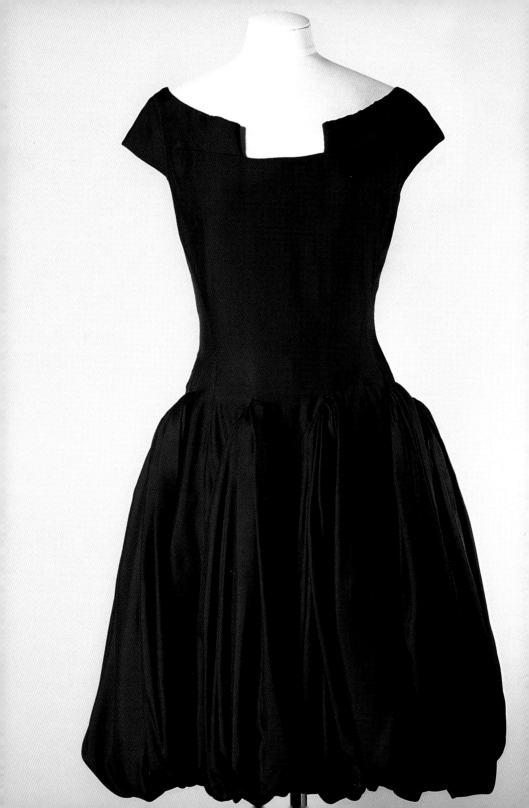

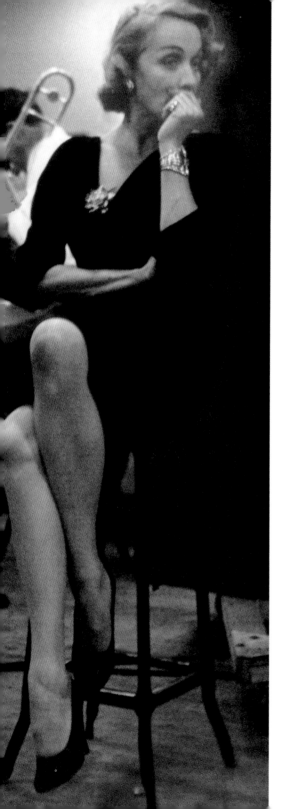

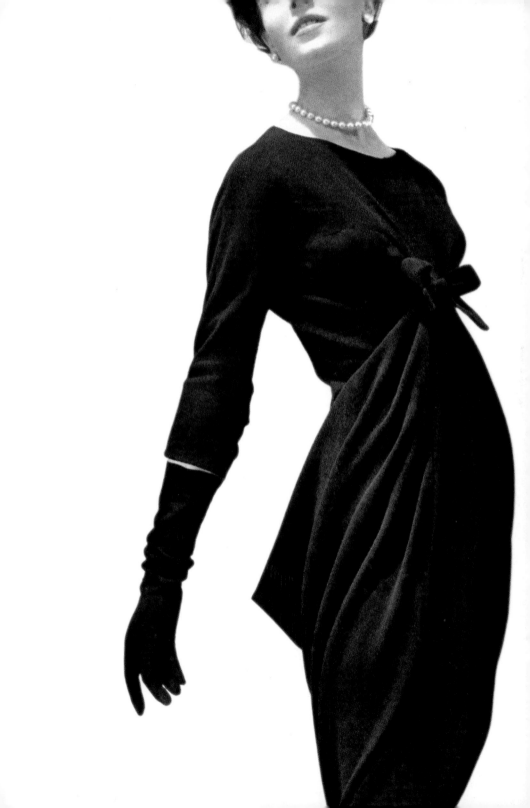

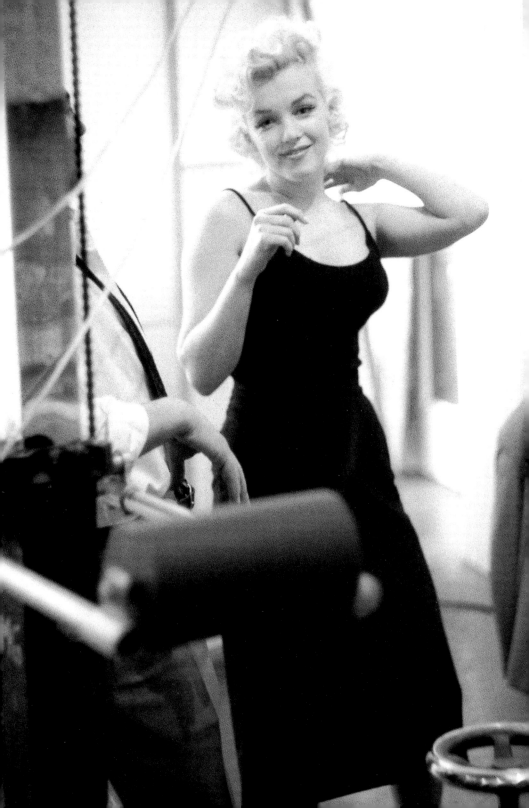

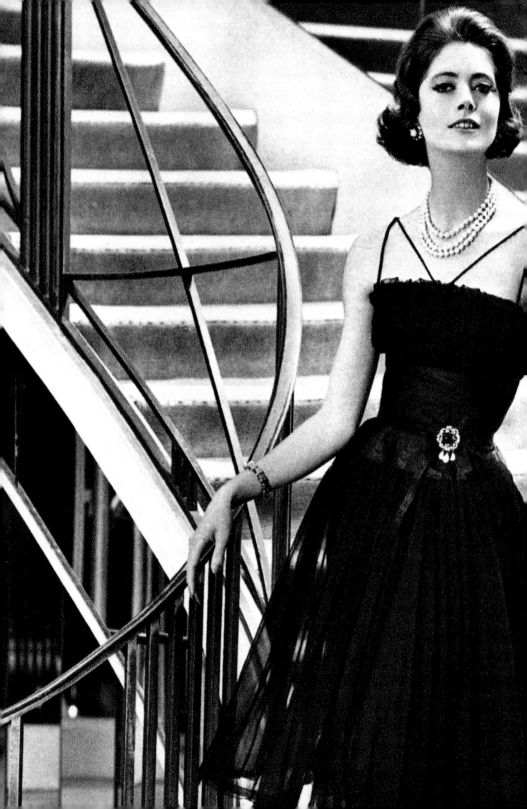

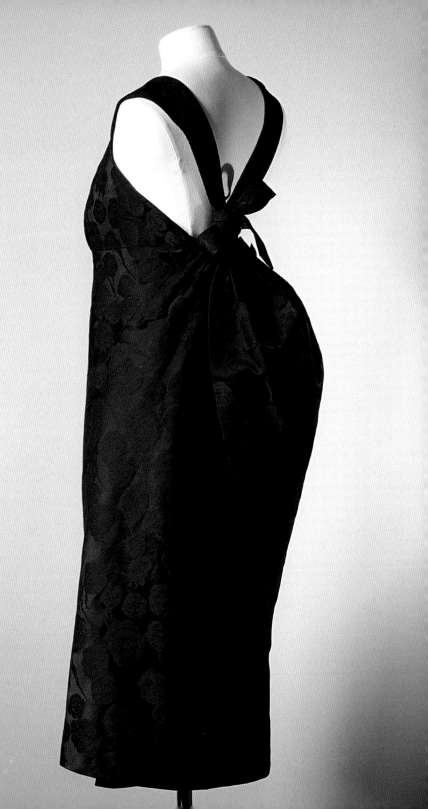

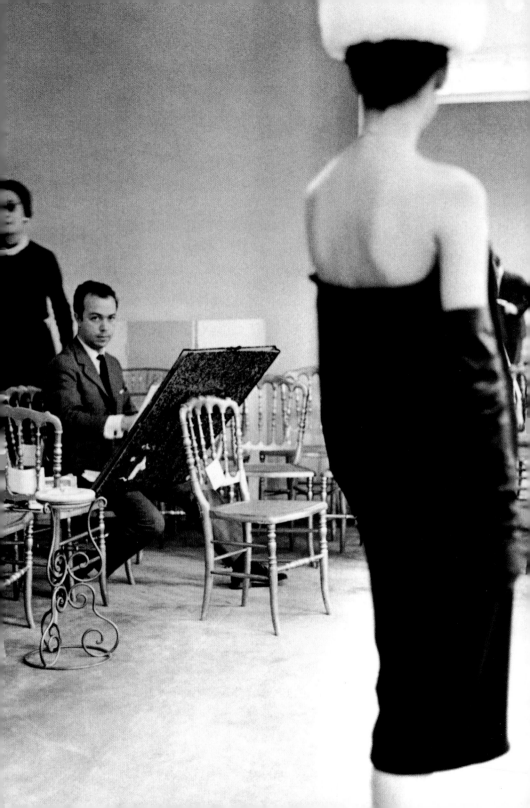

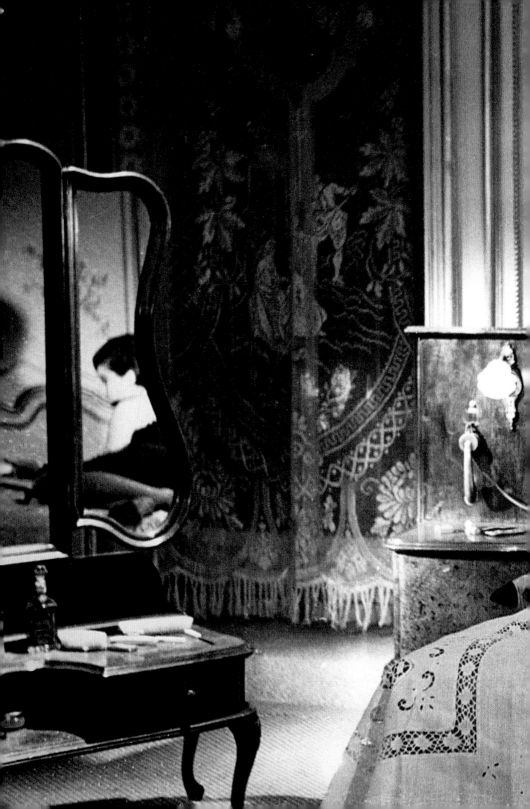

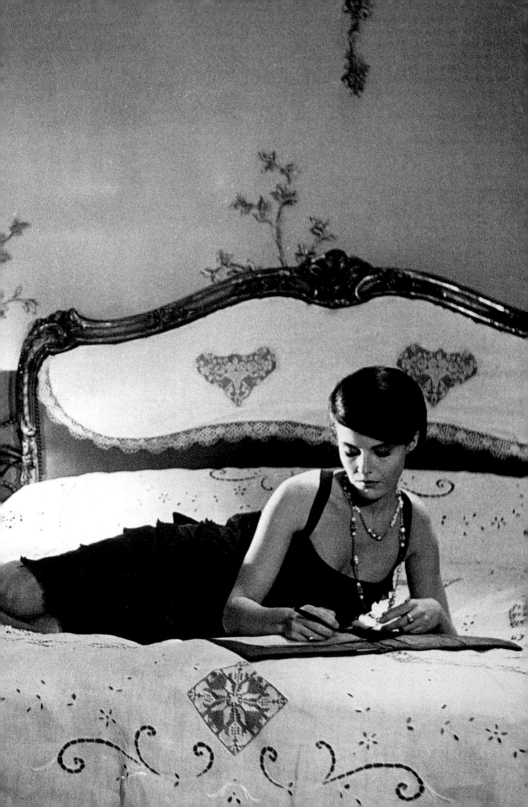

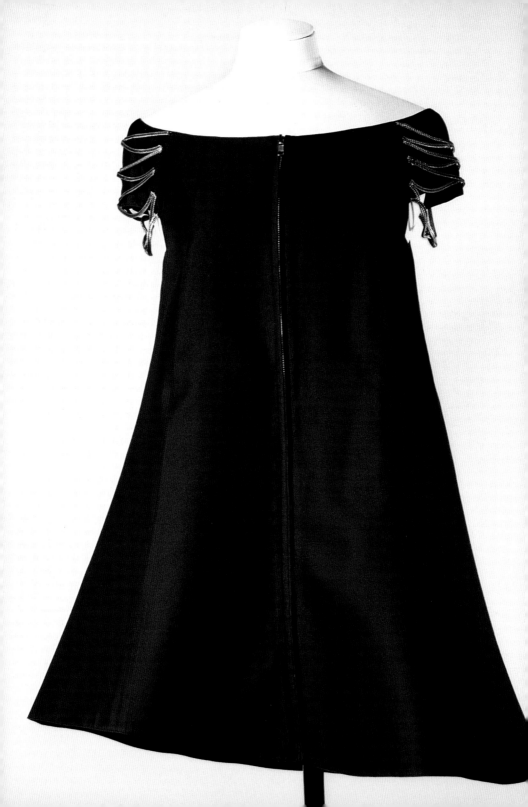

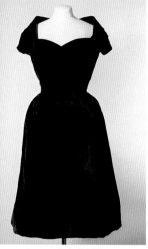

Jacques Fath, 1952

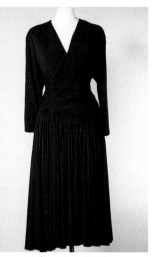

Madame Grès, 1942

Thierry Mugler, 1985

Balenciaga, 1939

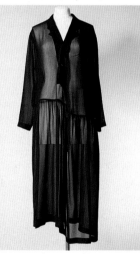

Comme des Garçons, 1987

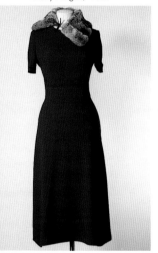

Prada, 2001

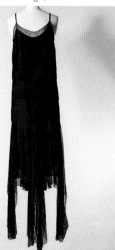

Lucien Lelong, 1928

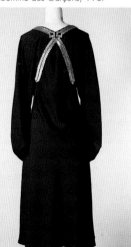

Lanvin, 1933

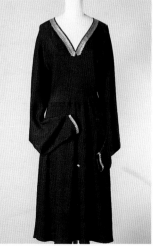

Lanvin, 1933

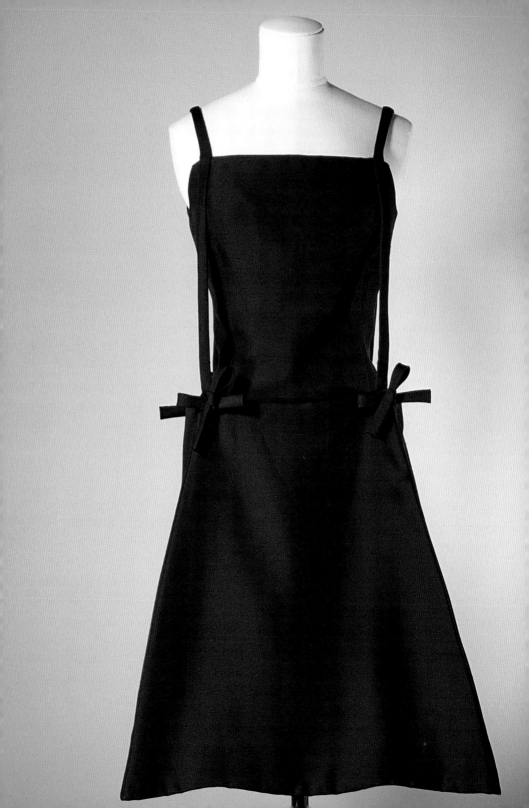

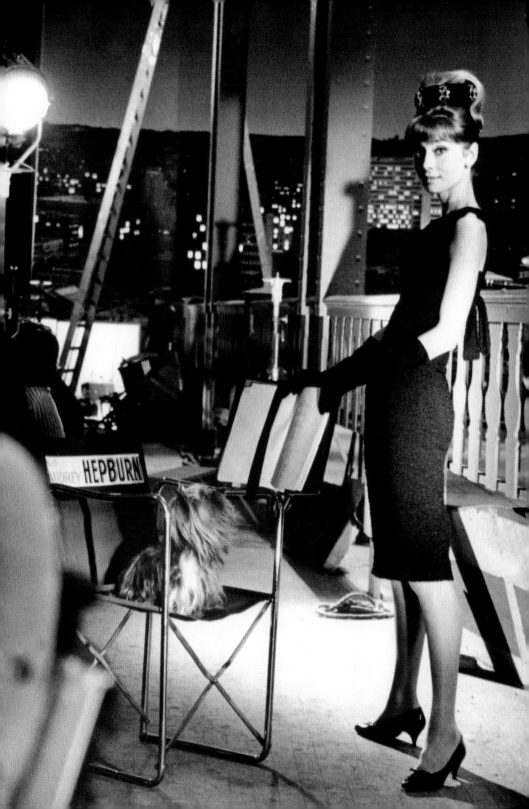

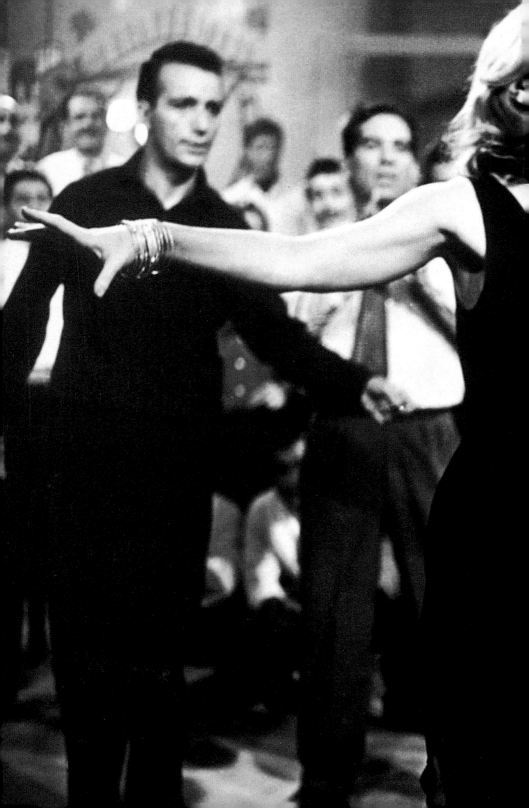

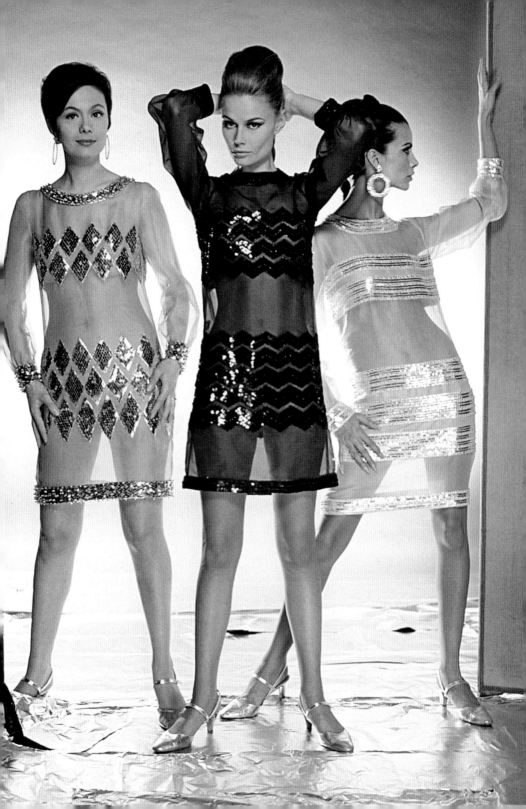

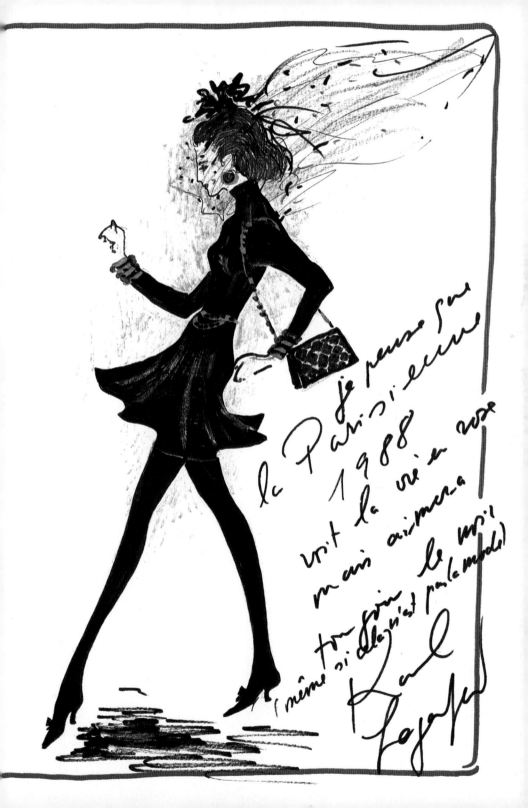

je pense que
la Parisienne
1988
voit la vie en rose
mais aimera
toujours le noir
(même si elle n'est pas la mode)
Karl
Lagerfeld

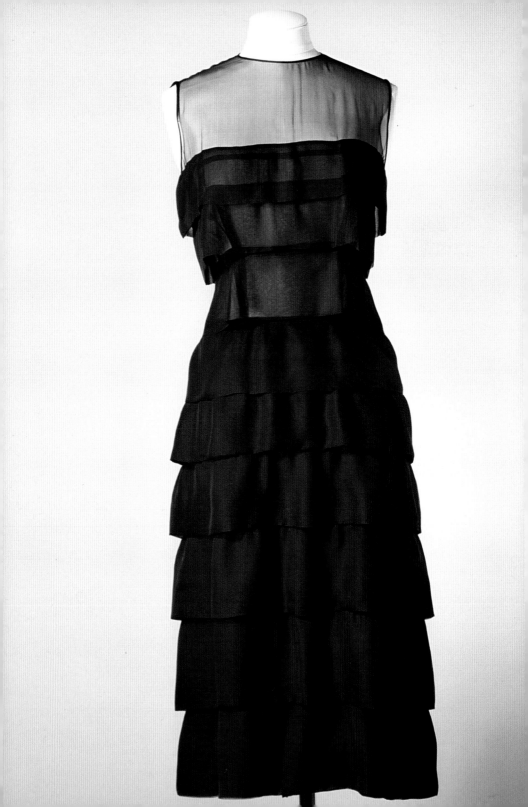

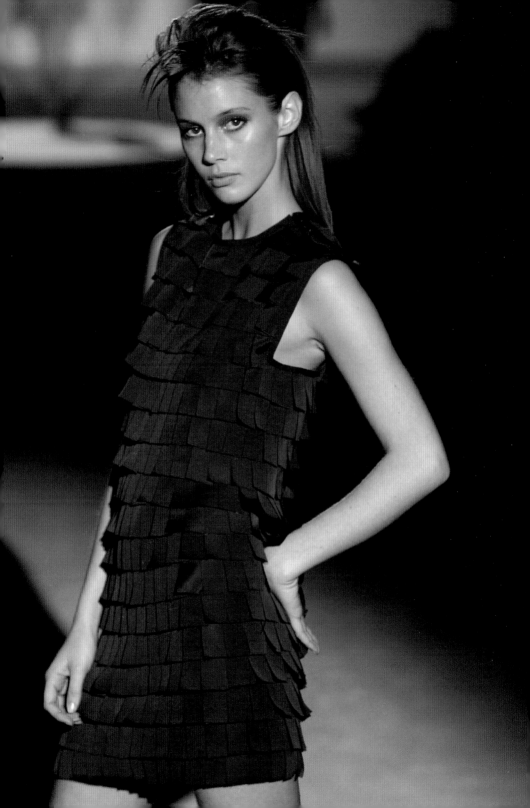

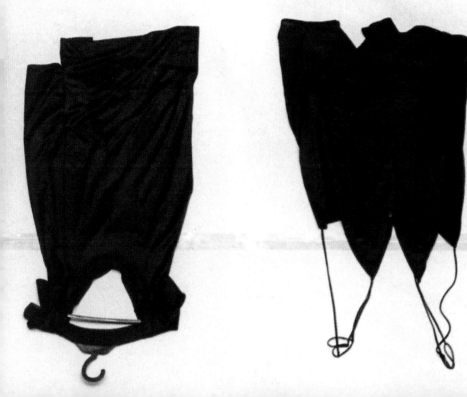

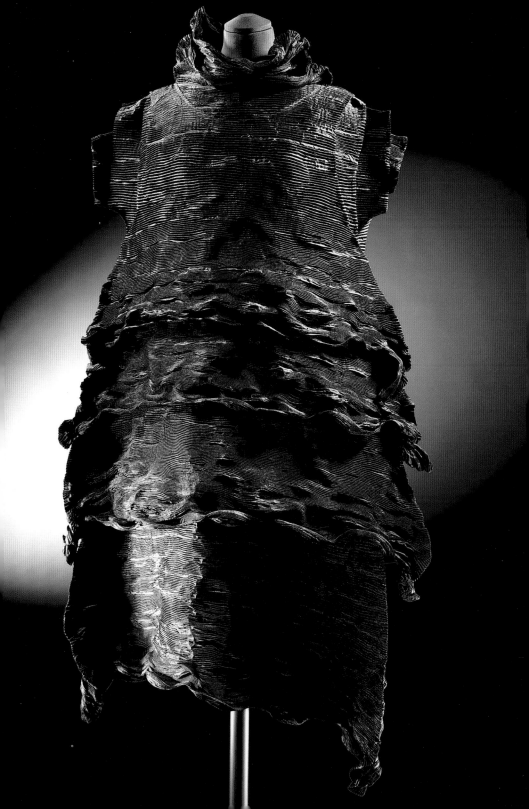

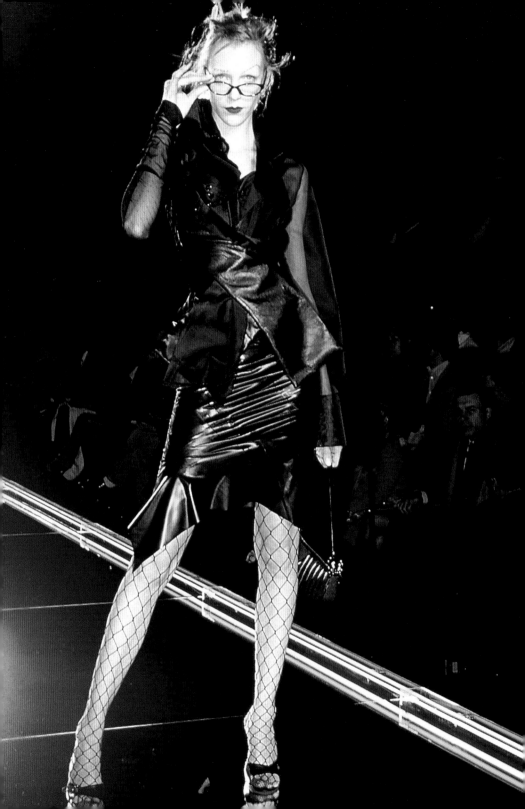

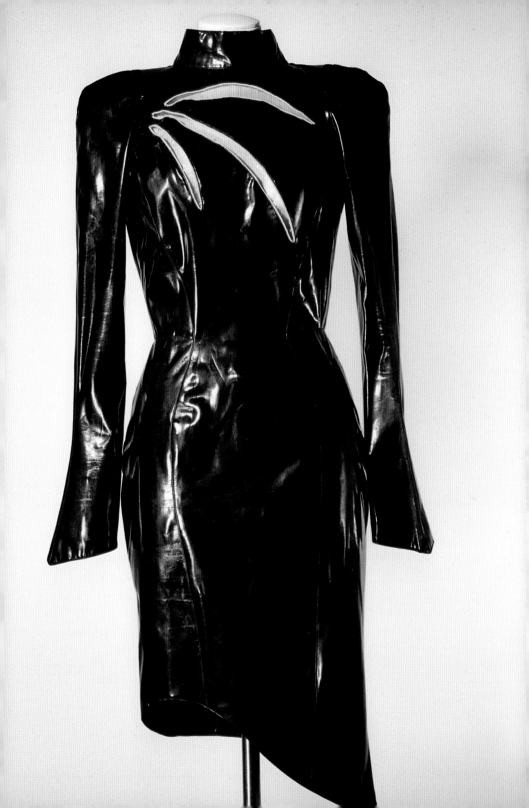

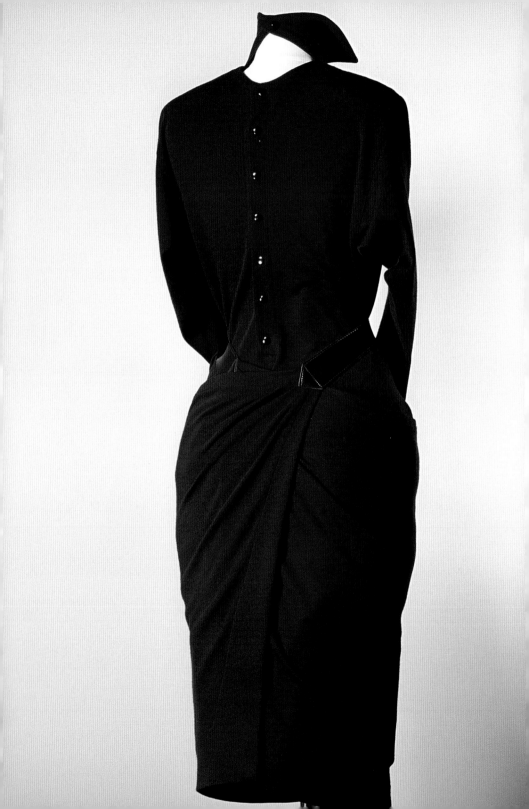

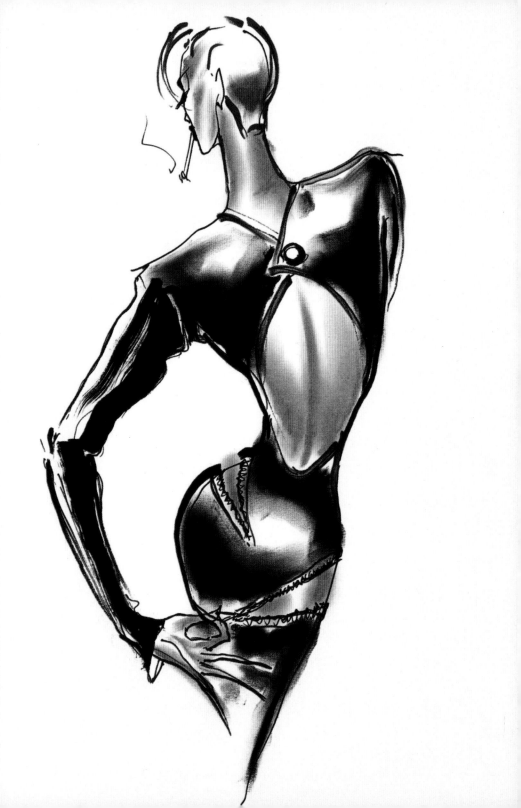

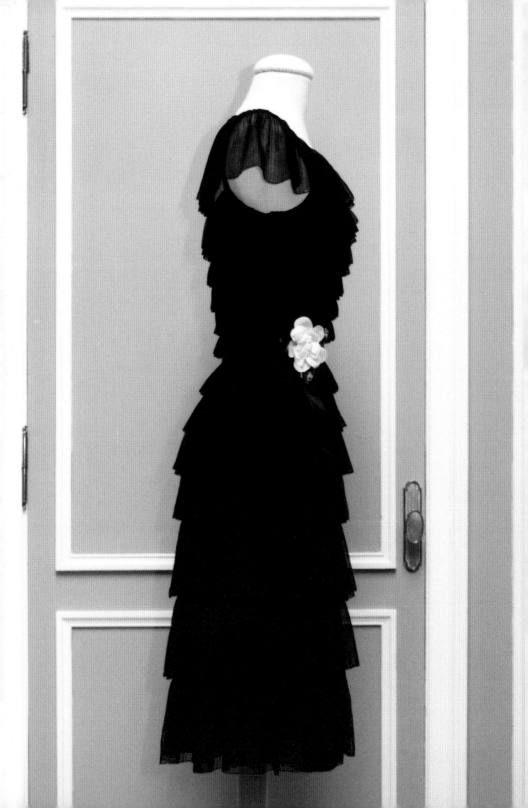

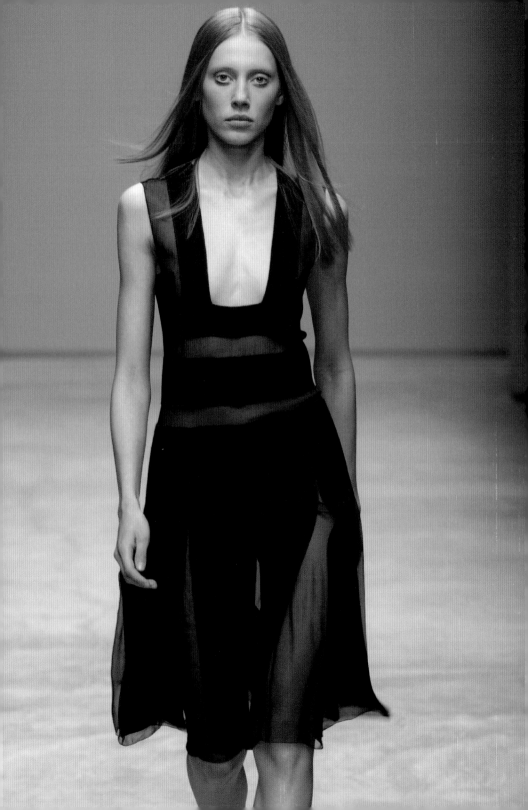

L'OFFICIEL

de la Couture et de la Mode d

COLLECTIONS
DE PRINTEMPS

N° 431-432 - Mars 1958
Prix : 1.200 francs

Christian Dior
Robe de ligne trapèze en Alaskine de Staron

Imprimé en France - Paraît tous les deux mois

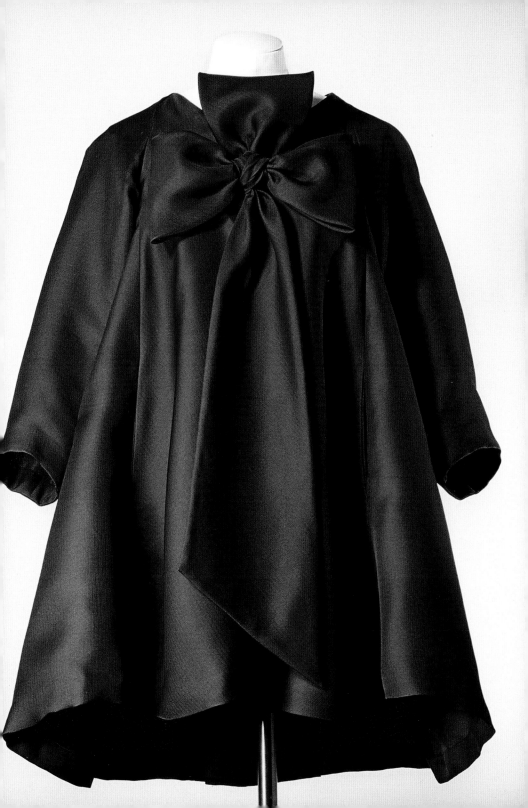

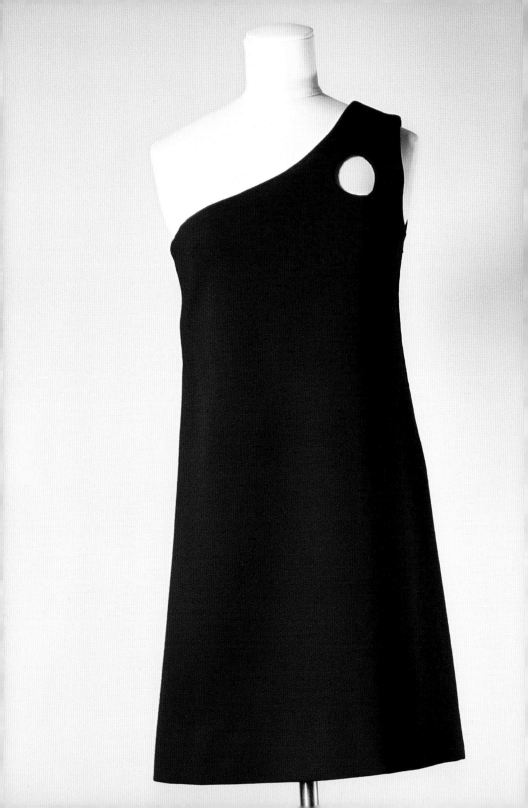

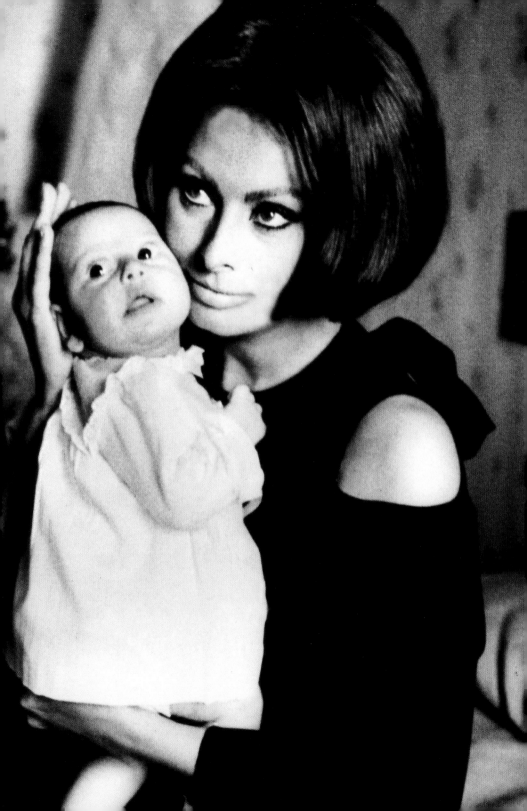

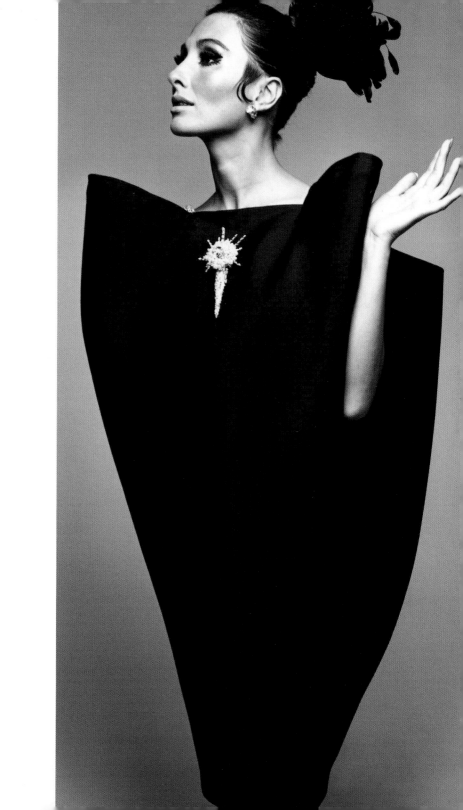

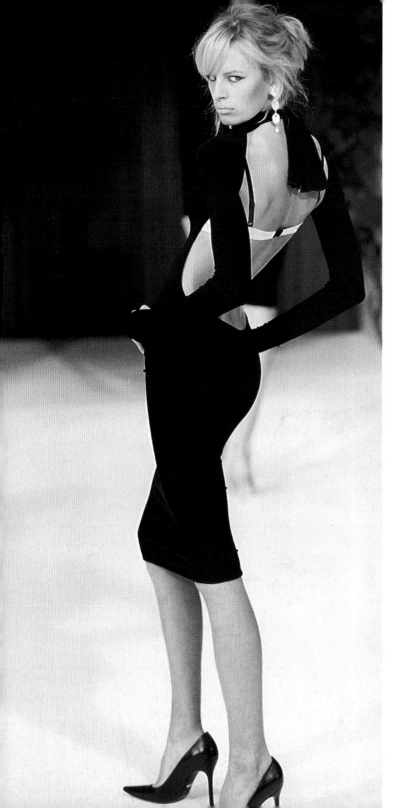

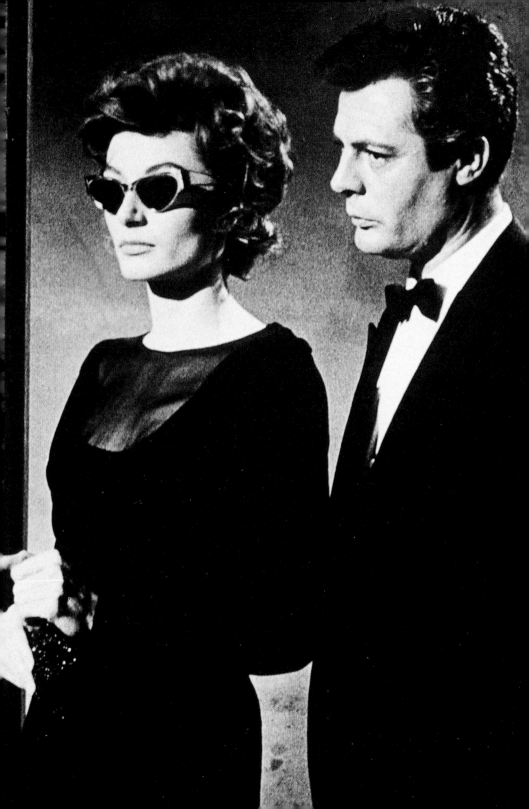

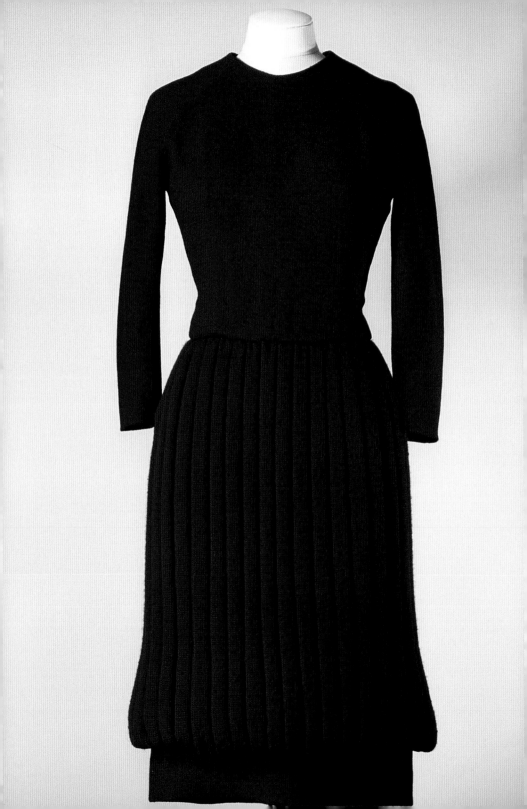

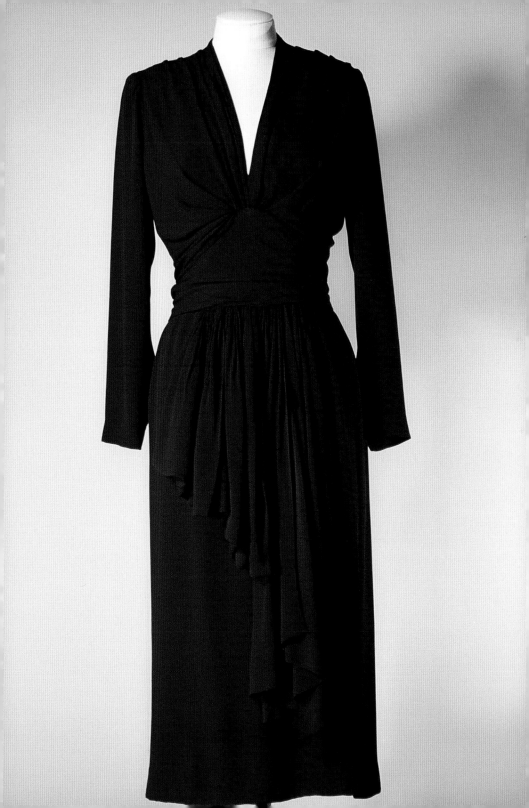

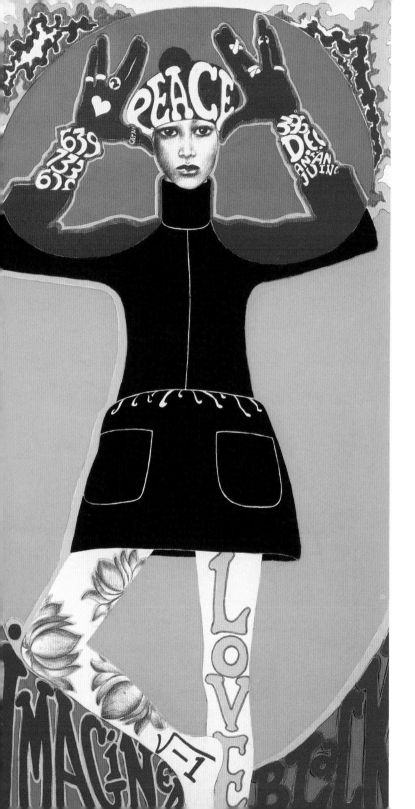

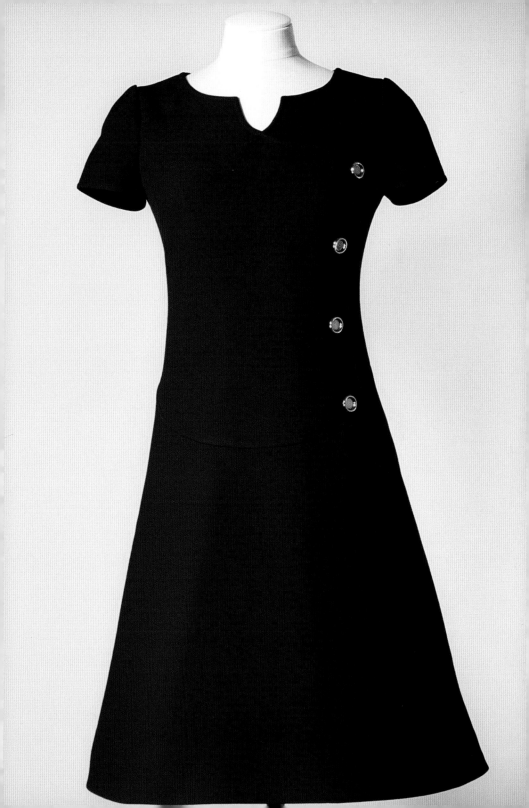

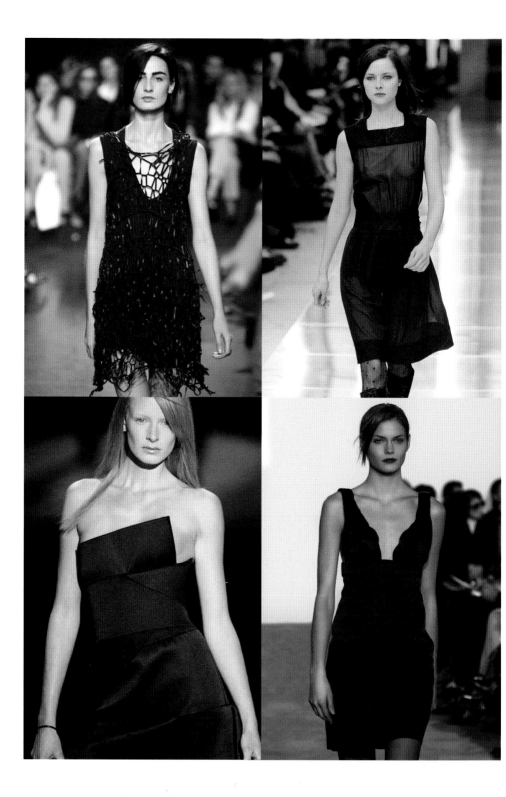

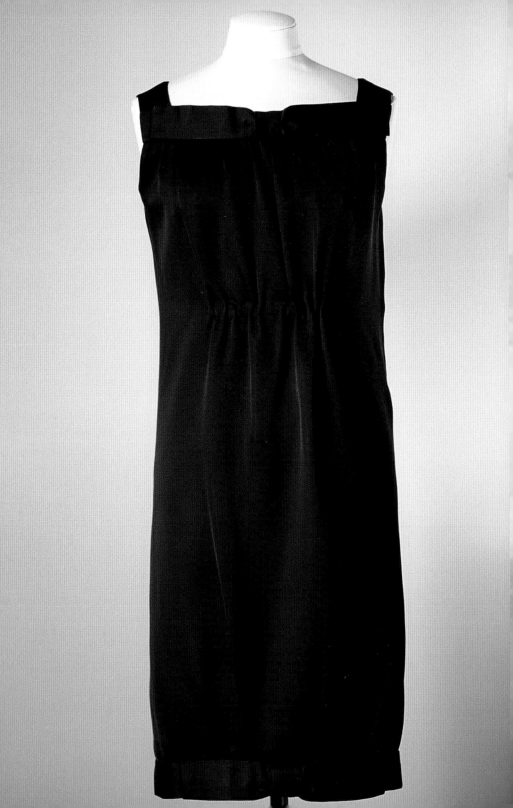

Chronology

1926: *The Little Black Dress comes onto the scene.*
Hairstyles are short, legs bared: Chanel creates the "Ford" model, soon to become the uniform of modern women, and invents "le chic pauvre."

1930: *The Little Black Dress is here to stay.*
The world of Parisian couture is in the hands of a generation of magicians: Chanel, Vionnet, Lanvin and Schiaparelli harness their considerable talents to serve the little black dress.

1937: *The Little Black Dress has two loves.*
Cristobal Balenciaga comes to Paris. Jacques Fath founds his own establishment.

1940: *The Little Black Dress joins the Resistance.*
Dignified, plain and discreet, the little black dress endures as a symbol of patriotic chic, despite the scarcity of fabrics. Thanks to Parisian ingeniousness, the dress keeps mocking the occupying forces.

1943: *The Little Black Dress becomes a fashion essential.*
Pierre Balmain, sharing responsibility with Christian Dior for Lucien Lelong's collections, presents an afternoon dress called Petit Profit, in black crêpe de chine over Praline (called Jeanine at the time). The dress was a huge success, with 360 items sold.

1945: *The Little Black Dress at the Théâtre de la Mode.*
To help revitalize French haute couture after the war, the designers take their creations on a world tour, showing them on little wire dummies designed by Eliane Bonabel, working under Christian Bérard (known as "Bébé"). The exhibition was inaugurated in Paris on March 27, 1945.

1947: *The Little Black Dress finds a New Look.*
Christian Dior presents his first collection in February 1947 at Avenue Montaigne. The revolutionary length and fullness of his models show the world that Paris is back in the forefront of fashion.

1953: *The Little Black Dress meets Sabrina.*
One year after his establishment opens at rue Alfred de Vigny, Hubert de Givenchy finds his muse: Audrey Hepburn.

1957: *The Little Black Dress goes into mourning.*
Three years after Jacques Fath, Christian Dior dies of a heart attack on October 23, after a game of canasta in Italy.

1960: *The Little Black Dress goes into film.*
With Antonioni, Resnais, and many more, the little black dress hits the silver screen. Cleverly dressing their heroines in black, the manipulators of the New Wave lay down their Queen of Spades to mark their distance from the Technicolor comedies of the 1950s, and succeed in getting away—without censorship—with a veneration for the modern femme fatale, by intellectualizing her indecent sensuality.

1962: *The Little Black Dress goes on parade at Rue Spontini.*
After moving to the Rue La Boëtie in September 1961, Yves Saint Laurent presents his first collection on January 29, with the little black dress taking pride of place.

1965: *The Little Black Dress goes mini.*
Courrèges waves his magic wand and fashion becomes radically younger.

1968: *The Little Black Dress sheds bitter tears.*
In despair at Balenciaga's retreat from fashion, Mona von Bismarck shuts herself away for three days at her Avenue de New York residence.

Givenchy, 1956 Autumn-Winter Collection. Informal dinner dress in duchesse satin decorated with small bows; perfection in the form of a little black dress. Didier Ludot Collection, Paris.

1970: *The Little Black Dress says "Peace and Love."*
Mini or maxi, the little black dress battles for a better world.

1971: *The Little Black Dress turns to "Remembrance of things past."*
Yves Saint Laurent presents a collection inspired by the war. Glancing over a lacy back immortalized by Jean-Loup Sieff, the little black dress laughs at its critics in the press.

1975: *The Little Black Dress finds a new master.*
Thierry Mugler presents his collection at Neuilly for the first time, in the studio of photographer Sam Levin.

1978: *The Little Black Dress goes to the Tuileries.*
Claude Montana, Anne-Marie Beretta and Sonia Rykiel parade their creations under canvas around the Grand Bassin. The age of the new designers begins.

1981: *The Little Black Dress brings the enfants terribles of fashion to their knees.*
It's the very first show for Comme des Garçons and Yohji Yamamoto, who intellectualize the color black and totally ignore the body's shape, and also for Jean-Paul Gaultier, the most Parisian of them all.

1985: *The Little Black Dress stars at the Palais Garnier.*
The world of fashion finally abandons its narrow view—held for far too long—of Azzedine Alaïa as the exalter of sexy couture, recognizes the genius and extreme inspiration of his styling and crowns his talent with 2 Oscars at the Palais Garnier: one for his Summer 1986 Collection, consecrated as Top Collection, and the other as Top Designer Award for the year 1985.

1987: *The Little Black Dress thrills to games of hide and seek.*
Christian Lacroix opens his own establishment after 5 triumphant years with Patou.

1989: *The Little Black Dress plays hunt the thimble.*
Showing his first collection for Dior, Gianfranco Ferré plays on the outrageous, with huge pearl buttons and a riot of organza flounces and satin ribbons. He receives the Dé d'or award—the golden thimble—for the little black dress shown in homage to Dior.

1990: *The Little Black Dress travels to strange places.*
The 6 d'Anvers parade their grunge dresses in black crushed wool through disused garages and railway stations.

1995: *The Little Black Dress invents the "fashion basic."*
Miuccia Prada and Calvin Klein create bourgeois minimalism, reinterpreting Jackie Kennedy's three-hole dress. Black is their inspiration and the foundation of all their collections.

1997–1998: *The Little Black Dress returns in style.*
Real values recognized: the vintage style, a genuine social phenomenon, takes over the fashion world. Each woman claims she's unique, and every fashion house draws deeply on its heritage, with Demi Moore and Stephanie Seymour playing ambassadress.

2000: *The Little Black Dress has fun below stairs.*
In his haute couture show for Christian Dior, John Galliano takes snobbery to the limit by presenting little black dresses with flounced aprons, lace caps and feather dusters.

2001: *The Little Black Dress skips into the Third Millennium.*
Black is the structure and trajectory of every fashion show. Coquettish, frivolous and capricious, the little black dress reigns airily supreme over the world of fashion.

Dress from Didier Ludot's 2001 Spring-Summer Collection, "Intermezzo" model.
© Gilles Trillard/Editions Assouline.

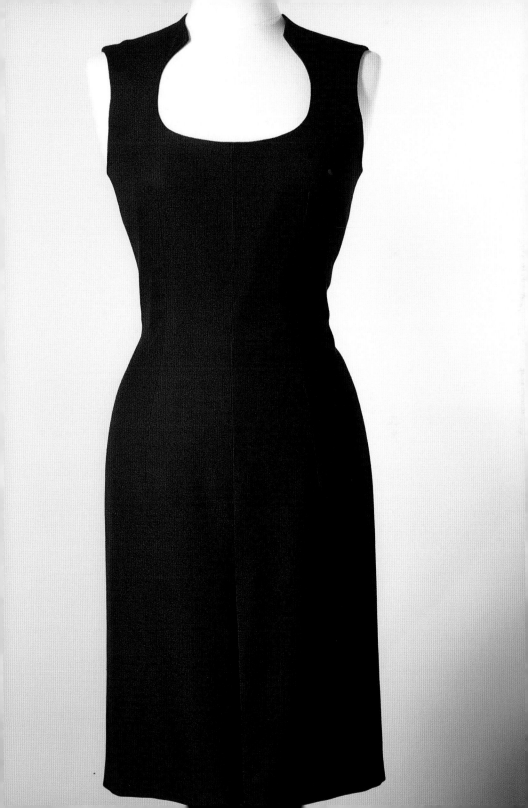

The little black dress

Coco Chanel in her "Ford" dress as seen by Karl Lagerfeld in a pencil sketch. A black crêpe sheath, as much the armor of the modern, independent woman as the functional bodywork of the Ford automobile. © Karl Lagerfeld/Chanel.
Mademoiselle Chanel working in her studio in 1962. © Douglas Kirkland/ Corbis AX022051.

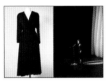

Yves Saint Laurent, 1972. A perfect shirt-dress in crêpe de Chine with box belt: the very essence of chic and simplicity. Didier Ludot Collection, Paris. © Gilles Trillard/Editions Assouline. **Edith Piaf at the Olympia** in 1961, wearing a dress by Jacques Heim: a frail silhouette in black springing out from the shadows of the stage against a great red curtain. Rising from the depths of her soul, her magnificent voice surges through the hall. © Yvon Bérangier/Musée Edith Piaf.

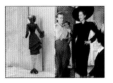

The Fashion Theatre in 1945. A model by Marcel Rochas shown on a dummy created by Eliane Bonabel. Black wool dress by Rodier, lace-covered satin hat. © David Seidner. **Maria Montez** trying on an afternoon dress at Jacques Fath's, with her husband Jean-Pierre Aumont. The young, famous, good-looking trio is the very image of the glamorous, carefree atmosphere that reigned at the time at the House of Jacques Fath. Photo published in *Fémina* magazine, November 1946. © Roger Schall.

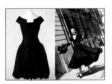

Christian Dior, 1955 Spring-Summer Collection. Afternoon dress in lightweight wool with pleated quilling. Didier Ludot Collection. © Gilles Trillard/Editions Assouline.
Diorama, 1947 Autumn-Winter Collection. Formal afternoon dress. This dress required 29.20 yards of black crêpe de Chine in a width of 51", 55 yards of plaiting and 230 hours of work, and weighs over 6.5 pounds. © Forlano/Diorama.

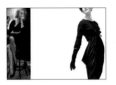

Marlene Dietrich recording in New York in 1952. Image of the cinema goddess whose face and voice were equalled only by the legendary perfection of her legs, set off here by a sheath dress. © Eve Arnold/Magnum, Paris. **Balenciaga, 1956.** Afternoon dress in wool crêpe. The fabric is draped towards the back and held with a bow under the breasts. An astonishingly modern design that appeared in *L'Officiel de la Couture* magazine in October 1956. © Seeberger/BNF, Paris.

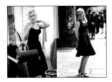

Marilyn, unknowingly photographed at Fantom Hill by Milton Greene, as luminously curvaceous and touching as her legend. © 2001 Milton H. Greene Archives, Inc. www.archivesmhg.com.
Catherine Deneuve at the première of Roman Polanski's film *Repulsion* in 1965. A contemporary look with sun-ray pleats and stiletto heels. © Rue des archives.

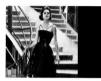

Chanel's black dance dress makes a comeback. 1962 Winter Collection. This black muslin model, featuring a skirt with crested pleats under a black satin corselet, was shown on the legendary staircase that appeared in issue no. 489 of *La Femme Chic* magazine. © Seeberger/BNF, Paris.

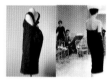

Balenciaga, 1960 Autumn-Winter Collection. Dinner dress in damasked silk by Staron. The asymmetrical back underlined by a shell reveals a master's touch. Didier Ludot Collection, Paris. © Gilles Trillard/Editions Assouline.
Watched by the illustrator Alfredo Bouret and Tina Sari from *Vogue* France, a model shows an informal dinner dress by Balenciaga: a silk crêpe sheath hints at the figure-molding dress shape beneath. 1957. © Kublin/Archives Balenciaga.

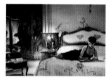

Delphine Seyrig, languorous and enigmatic in black muslin by Chanel, in Alain Resnais's dreamlike film *Last Year at Marienbad*, in 1961. © D.R./Prod. D.B.

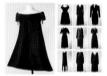

Montana, 1989. Mini-dress in double silk gazar, shoulders with silver chain feature, zip-fastened front. Asymmetrical hemline. Didier Ludot Collection, Paris. © Gilles Trillard/Editions Assouline. **Variations.** Jacques Fath, 1952; Grès, 1942; Thierry Mugler, Winter 1985; Balenciaga, 1939; Comme des Garçons, 1987; Prada, Winter 2001; Lucien Lelong, 1928; Jeanne Lanvin, 1933 (back and front). Didier Ludot Collection, Paris. © Gilles Trillard/Editions Assouline.

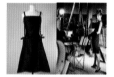

Marc Vaughan, 1971. Spectacular square dress in silk shantung illustrating the talents of a couturier who deserves to be better known. Didier Ludot Collection, Paris. © Gilles Trillard, Editions Assouline.
Audrey Hepburn with her dog, Famous, on a shoot for Richard Quine's *Paris When it Sizzles* in 1962, wearing a dress by Givenchy. © Bob Willoughby.

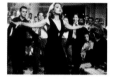

The plunging neckline of Melina Mercouri's dress emphasizes her warmly erotic presence in Jules Dassin's 1960 film *Never on Sunday*. © Christophe L.

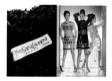

The first dress ever with the Yves Saint Laurent label was a little black dress. This sleeveless model in goffered georgette, created in December 1961 for Madame Arturo Lopez Willshaw, features a jet-embroidered top and a satin ribbon casually placed across the neckline. © Archives Yves Saint Laurent Haute Couture.
The daringly transparent Nude Look by Yves Saint Laurent, 1966. © P. Boulat/Cosmos.

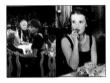

Stéphane Audran in Luis Buñuel's *Discreet Charm of the Bourgeoisie,* 1972. Dinner parties and expectant perversity. © Christophe L.
Jeanne Moreau in Louis Malle's *The Lovers,* 1958. Beauty at its most ardent and arousing in a Chanel dress. © Vincent Rosselle.

Romy Schneider embodies the ideal woman as seen by Coco Chanel. © Rue des archives.
Telling illustration of the love affair between the Parisian woman and her little black dress. A vivacious sketch by Karl Lagerfeld, 1988. © Karl Lagerfeld/Chanel.

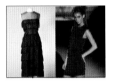

Chanel circa 1962. Silk muslin in the purest Chanel style. Didier Ludot Collection, Paris. © Gilles Trillard/Editions Assouline.
Gucci, 2001-2002 Autumn-Winter Collection by Tom Ford. Girl centurion's dress announcing the return of the miniskirt. © Patrice Stable.

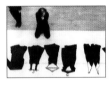

Yohji Yamamoto deep in thought on the sequence of designs to be taken down the catwalk at the 1991 Spring-Summer show. © Thierry Bouët.

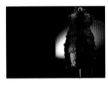

Issey Miyake, 1993 Spring-Summer Collection. The astonishing "Ecorce" dress, nothing less than a sculpture in pleated polyester. © V&A Picture Library.

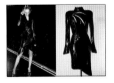

Christian Dior, 2001 Spring-Summer Haute Couture Collection by John Galliano. Glamour with whimsy. © Christian Dior Archives, Paris.
Thierry Mugler, 1985. Dress in vinyl, illustrating the typically 80s broad-shoul-dered look. Transparent motifs on the front, asymmetrical hemline. Didier Ludot Collection, Paris. © Gilles Trillard/Editions Assouline.

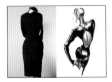

Azzedine Alaïa, 1981-1982 Autumn-Winter Collection. Wool jersey dress with rolled pinafore held by a black patent belt. From the dress collection of the famous model Bettina. Didier Ludot Collection, Paris. © Gilles Trillard/Editions Assouline.
The famous zip-fastened dress with porthole back, skillfully sketched by Thierry Perez. Azzedine Alaïa, 1981. © Thierry Perez.

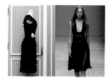

Chanel, Winter 1962. Layered flounces of ribbed muslin, satin belt with camellia decoration, Chanel's emblem. Didier Ludot Collection, Paris.
Prada, 2001-2002 Autumn-Winter Collection. The "petite Prada": demure and wanton, the liberated little black dress.

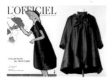

Cover of *L'Officiel de la Couture* magazine, March 1958. © Gruau/Galerie Sylvie Nissen.
Christian Lacroix, 1993 Spring-Summer Collection. Baby doll design in silk gazar decorated with a bow. Dominique Fallecker Collection, Paris. © Gilles Trillard/Editions Assouline.

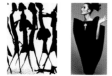

Pierre Cardin, 1969. Asymmetrical mini–dress in jersey by Racine, a perfect illustration of the designer's taste for the geometric. Didier Ludot Collection, Paris. © Gilles Trillard/Editions Assouline.
Sophia Loren and Carlo Ponti Junior in 1973. The tenderness of a screen star mother of Madonna-like beauty. © Imapress/Globe Archive/Globe Photos Inc. 1973.

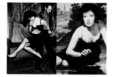

Paloma Picasso dancing with Xavier de Castellane at a party thrown by Antonio at the Privilège in 1983. © Roxanne Lowit, 1983.
The torrid sensuality of Monica Vitti, the inspiration for Antonioni in *La Notte*, 1960. © T.C.D./D.R./Prod. D.B.

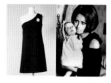

René Gruau. 1955 cover for *International Textile* magazine. © Gruau/Galerie Sylvie Nyssen.
The last word in Balenciaga. 1967 winter dress in black gazar by Abraham: short, narrowly tapering skirt flaring into four folds held by strass straps. © Hiro.

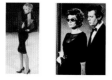

Dolce & Gabbana's 2001 Spring-Summer Collection. This model demonstrates their flair for modern interpretations of the little black dress. © Patrice Stable.
Anouk Aimée with Marcello Mastroianni in Fellini's *La Dolce Vita*, 1959. A somber beauty exhausted by too many sleepless nights in a no-man's-land between dreams and reality. © Cat/Kipa.

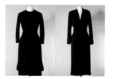

Christian Dior by Yves Saint Laurent, 1959 Autumn-Winter Collection. A barrel-dress in a novel alliance of wool crêpe and knit. Didier Ludot Collection, Paris.
Lucien Lelong, 1945. Dress in crêpe marocain, featuring gathers on the shoulders flowing into a draped front. Created by Christian Dior, Lelong's artistic director at the time (and for the following year). Didier Ludot Collection, Paris.

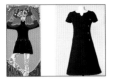

Antonio's little black dress carries a message of Peace and Love, influenced by the Beatles. *Fashions of the Times*, 1967 (felt and colored patent). © Antonio. **Courrèges, 1965.** Knit fabric, oversewn seams decorated with steel buttons. Didier Ludot Collection, Paris. © Gilles Trillard/Editions Assouline.

Variations. Anne Demeulemeester, Spring-Summer 2001; Helmut Lang; Yves Saint Laurent Rive Gauche, Autumn-Winter 2001-2002; Louis Vuitton. © Patrice Stable. **Hugo Boss, 2001.** © Greg Mc Dean/Hugo Boss.

The author and the publisher wish to thank Felix Farrington, Dominique Fallecker, Seïchi Hibiki, Miuccia Prada, Mirabelle Sainte-Marie, the Musée des amis d'Edith Piaf, the Chanel Archives (Marika Genty), the Balenciaga Paris Archives (Marie-Andrée Jouve), the Christian Dior Paris Archives (Soizic Pfaff, Barbara Jeauffroy), the Yves Saint Laurent Haute Couture Archives (Hector Pascual, Pascal Sittler), the Stockman house.